The Yellow Book

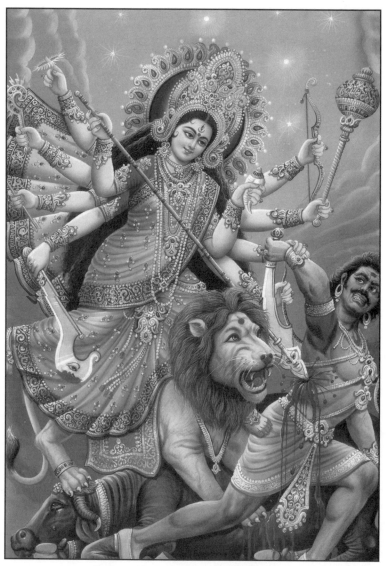

THE DIVINE MOTHER KUNDALINI SLAYS THE DEMON-EGO

The Lady of supreme adoration takes Her
children by the hand and guides them along
the dangerous path of the razor's edge.

THE YELLOW BOOK

GNOSIS, THE DIVINE MOTHER KUNDALINI, AND JINN SCIENCE

Samael Aun Weor

THELEMA PRESS
2007

Publisher's Notes

1. When seen in this book, the symbol † indicates additional information available in the Glossary on page 207.

2. In order to make clear the instructions given in this book, we have divided the practice of Christic Egyptian Pranayama into two parts: one for men, and one for women. Although originally given as a single practice and followed by a small note for women to invert the technique, this resulted in a great deal of confusion for students. Therefore, in this edition, the practice has been written exactly as required for each sex. Otherwise, this text remains as originally composed.

The Yellow Book
A Thelema Press Book / April 2007
Second Edition (English)

Originally published as "El Libro Amarillo," 1959

This Edition © 2007 Thelema Press

ISBN 978-1-934206-12-6

Thelema Press is a non-profit organization delivering to humanity the teachings of Samael Aun Weor. All proceeds go to further the distribution of these books. For more information, visit our website.

www.gnosticteachings.org
www.gnosticradio.org
www.gnosticschool.org
www.gnosticstore.org
www.gnosticvideos.org

Contents

Introduction

The adorable Mother Kundalini is the burning fire of the Holy Spirit. She is Mary, Maya, Isis, Adonia, Insoberta, Rea, Cibeles, etc., etc., etc.

She has thousands of adorable names. She is Love, Electricity, Universal Magnetism, Cosmic Force. The laws of cohesion and planetary gravity were created by the Mother of all adoration. All of the brilliant, sparkling and palpitating planets in the inalterable, adorable, infinite space rest within the delectable bosom of the blessed Mother Goddess of the world.

The Lady of supreme adoration takes Her children by the hand and guides them along the dangerous path of the razor's edge.

The Divine Mother is entwined three and a half times within the coccygeal church. The Lady of all adoration opens the seven apocalyptic churches of the spinal medulla.

We must search for the Divine Mother within our Heart Temple. The Cross of the Initiation is received within the Temple of the Heart. She, the adorable Lady of love is the only one who has the power of awakening Her children within the womb of the profound Universal Spirit of Life.

The mind must become a serene lake, without tempests, so that it will reflect the picture of the starry skies. When the mind is quiet and silent, the Divine Mother is then pleased with us.

This is our blessing. Peace is possible only by controlling the mind. Purity of thought guides the Yogi towards perfection.

We must venerate the Masters and we must practice our esoteric exercises filled with burning faith.

The initiates with faith will become ineffable beings. Wisdom and Love will shine in the minds of those who have reached Samadhi, the ecstasy of Saints. All of our beloved disciples can become true Masters of Samadhi with this book of flaming fire.

Beloved brothers and sisters, arise upon the path of Initiation prudently. Remember that this path is full of dangers internally and externally. This is the path of the razor's edge.

Drink the nectar of immortality from the pure fountain of ecstasy. Tread the path of perfect sanctity.

The Divine Mother has the power to open up all of the chakras of the Astral Body. The Lady of perfection dwells within the electrons. Wise Gnostics meditate on Her. Mystics adore Her. Perfect couples lift Her up through the medullar canal by means of love.

Take care of your seminal liquor. Avoid nocturnal emissions with the Arcanum A.Z.F.

Muscles must be relaxed for meditation; the spine must be kept flexible. We must drink pure water and we must rise at dawn. Remember that honey (bee honey) is the food of the Universal White Fraternity. Eat fruits, grains, and vegetables often and practice meditation daily. Remember that meditation is the daily bread of the wise.

The Yellow Book is a book of absolutely practical transcendental occultism. Beloved brothers and sisters, here you have the Yoga that is required for this new Aquarian Era.

Be gentle in order to listen; merciful in order to judge.

May your Father who is in secret and may your Divine Mother Kundalini bless you.

Samael Aun Weor

Chapter 1

Love

The Yoga that we require today is actually ancient Gnostic Christian Yoga, which absolutely rejects the idea of Hatha Yoga. We do not recommend Hatha Yoga simply because, spiritually speaking, the acrobatics of this discipline are fruitless; they should be left to the acrobats of the circus.

We very sincerely believe that the greatest thing in life is love. The divine enchantment of love can never be replaced by circus acrobatics. In the mysteries of Eleusis, men and women would magnetize one another while performing the mysterious dances of love.

During the great celebrations of Eleusis, happiness, dancing, kissing, and performing sexual magic transformed human beings into true Gods. At that time, no one thought about perversities, only about holy and pure matters.

Within the delights of love, men and women can enchant and awaken the sleeping beauty, the divine serpent Kundalini. When one woman and one man adore each other sexually, they accumulate the terribly divine power of the Cosmic Mother.

These frightful, yet divine, sparkling forces overflow with great splendor and activate the chakras of the internal bodies of the human being. Chakras are the great energy centers which resemble wheels or lotus flowers.

The fires of the spinal medulla are Jehovistic; the fires of the heart are Christic and the fires of the head (between the eyebrows) spark the terribly divine rays of the Father.

Essentially, these three types of energy are transmuted semen.* The code or key of human redemption is found in the seminal liquor.

The seminal energy must he sublimated towards the heart. The Divine Mother finds Her Son, the internal Christ within the heart.

* EDITOR'S NOTE: According to Scientific Chastity, "semen"
refers to sexual energy in both men and women.

The Mother and Her Son live within the heart temple; the Cross of Initiation is received in the heart temple.

There must be a sexual connection between the couple; however, it is better to die than to commit the crime of spilling the semen.

When the magician spills the Glass of Hermes, the terribly divine forces of the Goddess Isis (whose veil no mortal has lifted) withdraw. Then, these forces fuse within the universal currents and the human being submerges into the Abyss.

The tremendous mantra **I. A. O.** (pronounced *eeeee aaaa oooo*) synthesizes the science of the Arcanum A.Z.F. This mantra should be vocalized during the beloved ecstasy of sexual magic.

> **I** (*Ignis,* Fire)
>
> **A** (*Aqua,* Water)
>
> **O** (*Origo,* Principal Spirit)

The fire fecundates the waters of life in order to give birth to the Son of Man.

The Son of Man is always the son of one man and one woman. When they adore each other and perform the Arcanum A.Z.F. they are inevitably converted into Gods.

We should cultivate happiness, music and flowers in our homes. The couple must forgive one another, for they have many human defects. Nobody is perfect; the couple must mutually forgive their very human errors.

Love is not guilty of the discords between the lovers who adore one another. Discord belongs to the psychological "I" (Satan).

Gnostic Christian Yoga is composed of love, music, dance, perfumes, kisses, adoration, pranayama, meditation, illumination, wisdom and happiness. This modern Yoga follows Christ and adores the woman. The times in which the anchorites were tortured by Hatha Yoga has passed. Now, the modern male and female Yogis can be loving and adoring.

Love is ineffable. Love is terribly divine.

Chapter 2
The Kundalini

The Kundalini is the primordial energy enclosed within the Church of Ephesus. This Church of the Apocalypse (Revelation) is a magnetic center located two fingers above the anus and two fingers below the genitals (centered between the anus and the genitals).

The Kundalini is the igneous serpent of our magical powers. This sacred serpent, which is coiled up three and a half times is dormant within the Church of Ephesus. The Kundalini is the Divine Mother. The Kundalini is the Pentecostal Fire. The Sanctuary of the Divine Mother is located in the heart.

The Kundalini develops, evolves and progresses within the aura of Mahachohan (the Cosmic Mother, the Holy Spirit, the Third Logos).

The fires of the spinal medulla are Jehovistic. The fires of the heart are Christic. The fires of the head (between the eyebrows) spark the terribly divine rays of the Father.

The ascent of the sacred serpent through the medullar canal is controlled by the fires of the heart. The Kundalini evolves and progresses according to the merits of the heart.

The Kundalini must ascend towards the brain; it must then proceed towards the sacred sanctuary of the heart.

The Kundalini dwells within the electrons. Sages meditate on the Kundalini. Devotees adore and worship the Kundalini in their homes of perfection.

When the solar and lunar atoms unite, we drink the nectar of immortality because the Kundalini has awoken. The solar and lunar atoms unite in the Triveni, which is located near the coccyx. Then by way of electric induction, the union of these atoms awakens the Kundalini.

The Kundalini awakens with sexual magic combined with pranayama, concentration, meditation, profound devotion, willpower, comprehension and sacred mantras. The awakening of the Kundalini can be assisted with the actions of a Master of Major

The Seven Chakras / Churches

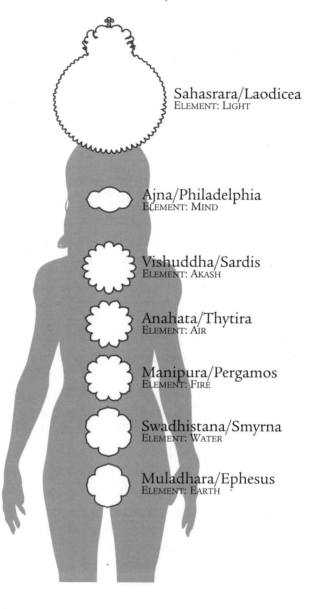

Sahasrara/Laodicea
ELEMENT: LIGHT

Ajna/Philadelphia
ELEMENT: MIND

Vishuddha/Sardis
ELEMENT: AKASH

Anahata/Thytira
ELEMENT: AIR

Manipura/Pergamos
ELEMENT: FIRE

Swadhistana/Smyrna
ELEMENT: WATER

Muladhara/Ephesus
ELEMENT: EARTH

Mysteries of the White Brotherhood†, or by the grace of our Divine Mother, if it is Her will.

The Kundalini cannot be awakened if the Yogi spills the semen. The ascent of the Kundalini through the medullar canal is a very slow and difficult process. The path of the igneous serpent, from one vertebra to another, signifies terrible ordeals, trials, frightful sacrifices and supreme purification. We must not only kill desire, but moreover, we must kill the very shadow of desire. Our motto is Thelema (willpower).

When the Kundalini reaches the pineal gland, which is situated in the upper part of the brain, we obtain perfect ecstasy.

We must be made aware of the fact that even though the Kundalini has the form of a serpent, in front of the devotee it can also take the form of the Divine Mother Isis, Rhea, Cibeles, Mary, etc.

When the Kundalini awakens, the devotee sees marvelous visions and hears multiple sounds. When the Kundalini awakens, it develops all of the powers of the soul. When the Kundalini awakens one sees a very brilliant, sparkling light that is equivalent to 10,000 suns which shine with happiness all on their own accord, along with the church of Ephesus.

If the devotee spills the semen after having initiated the ascension of his Kundalini through his medullar canal, the Kundalini then descends one or more vertebra, according to the extent of the fault. Thus, a fornicator can never reach realization of the Cosmic Self.

Water is the habitat of fire; if we spill the water, then we lose the fire. Chastity is the foundation of the great work. All of the powers of the Kundalini are found within the semen.

Whosoever raises the energy of the Kundalini to the pineal gland, actually achieves supra-consciousness (Nirvikalpa Samadhi State). The person who reaches this higher state is an illuminated one, a God.

The Kundalini dwells within the triangular cavity known as the Celestial Triangle. This is the center of the church of Ephesus. This marvelous temple of Ephesus is a splendid lotus of four petals. The church of Ephesus has the luminosity of 10,000,000 suns.

The earth elemental of the Wise corresponds to this lotus flower. When the sacred serpent opens the Church of Ephesus, powers over the elemental creatures that live in the womb of the earth are then granted to us. We then have control over earthquakes.

When the serpent ascends to the height of the prostate (uterus), the Church of Smyrna is opened. This chakra has six petals and confers the powers of creation. Creation is not possible without the prostatic chakra. The supreme rector of the prostatic Chakra is the immortal Babaji, a Yogi Christ from India whose physical body has existed for millions of years that are lost in the night of time. Babaji drives all life and has the power to create and create again. The elemental water of the Wise (Ens Seminis) is the element of this chakra. Whosoever opens the church of Smyrna has the power to control the waters and tempests.

When the Kundalini rises to the region of the navel, it bestows the power of control over the fires of volcanoes. The church of Pergamus is located in this region of the navel. This chakra has ten petals. The fire elemental of the Wise is the element of this chakra.

When the Kundalini reaches the heart it opens up the chakra of Thyatira. This grants us the power to work with the four winds. The lotus of the heart has twelve petals and its element is the air elemental of the Wise. Whosoever wants to learn how to enter into the supra-sensible worlds with the physical body must awaken the chakra of the heart. This is what is known as "Jinn" science. Then, indeed, the human body can leave the physical plane and enter the supra-sensible worlds. When the sacred serpent reaches the heart it opens the church of Thyatira and transforms us into intuitive human beings.

When the Kundalini has risen to the region of the larynx it grants the power of hearing the voices of those beings that live in the supra-sensible worlds. The Church of Sardis is in the chakra of the larynx; this chakra has sixteen petals. When the Kundalini reaches this height, it flourishes upon our fertile lips made verb.

When the Kundalini reaches the mid brow it opens the Church of Philadelphia. The point between the eyebrows is known as the Eye of Wisdom. The Father dwells within this magnetic center.

The chakra of the midbrow has two petals; it is the throne of the mind.

When the mind-matter is transformed into Christic-mind, we attain the mantle of the Buddhas and the Eye of Shiva. Anyone who awakens this chakra becomes clairvoyant.

When the Kundalini reaches the pineal gland it opens the church of Laodicea. This chakra has 1,000 splendid, sparkling petals. This is the crown that shines like an aura of light upon the head of the Saints. The atom of the Holy Spirit exists in the pineal gland. It is in this church that we attain the white dove of the Holy Spirit; here we fill ourselves with illumination, wisdom and omniscience.

In the Church of Ephesus we conquer the Earth. In the Church of Smyrna we conquer the Water. In the Church of Pergamus we conquer the Fire. In the Church of Thyatira we conquer the Air. In the Church of Sardis we conquer the Akasic fluids. In the Church of Philadelphia we conquer the Mind. In the Church of Laodicea we conquer the Light.

This is how we become kings/queens and priests/priestesses of Nature according to the Order of Melchizedek.

The atom of the Father is found within the magnetic center at the root of the nose. The atom of the Son is found in the pituitary gland and the atom of the Holy Spirit is found in the pineal gland.

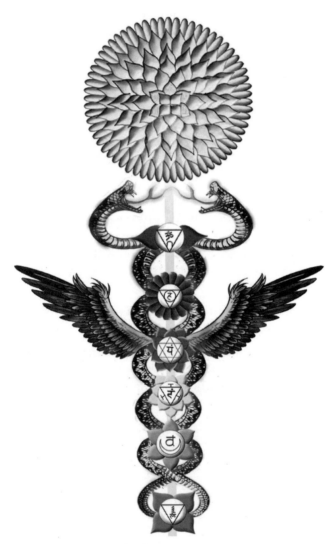

THE CADUCEUS OF MERCURY

Chapter 3
The Two Witnesses

The two witnesses that are entwined around the spinal medulla form the holy eight.

These two witnesses, entwined around the dorsal spine, form the Caduceus of Mercury.

The two sympathetic cords are situated on both the right and the left sides of the spinal medulla. The two witnesses rise, alternating from left to right, until they form a marvelous knot in the space situated between the two brows. They then continue until reaching the nostrils. The sympathetic cord from the right side rises and ends on the left side and vice versa. The cord that comes from the left side is cold; the cord that comes from the right side is hot. Cold is lunar; hot is solar.

The solar and lunar atoms of our seminal system rise through these two sympathetic cords until they reach the brain. When the solar and lunar atoms come into contact within the coccyx, the Kundalini inevitably awakens.

The medullar canal has an interior orifice that is normally closed among ordinary people. The seminal steam uncovers this orifice in order for the Kundalini to enter through it. In Gnostic Christian Yoga, there is a special exercise that is practiced in order to open this orifice more rapidly. This exercise is known as Pranayama.

When the Kundalini rises victoriously from chakra to chakra, it unties the knots and the impediments that oppose its ascension.

It is necessary to warn the Gnostic brothers and sisters about the importance of polarizing the sacred fire of the Kundalini. Some devotees enjoy sexual passion daily even when they do not spill the semen. The result of such acts is the polarization of the fire within the chakras which are situated in the lower abdomen. This is how they lose the happiness of enjoying the lotus of 1,000 petals, the Church of Laodicea. The lotus of 1,000 petals is the Diamond Eye which grants us the perfect ecstasy and the ineffable happiness of the human Gods. The Church of Laodicea gives us

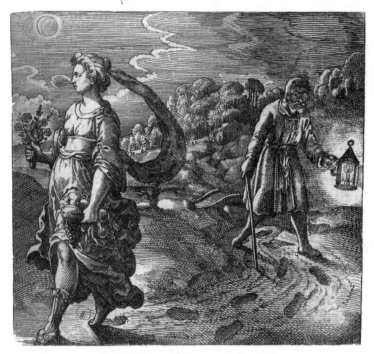

Those who are working with the Kundalini must
have an unbroken faith in the Divine Mother.

the power to consciously project, in spirit and in truth, in order to travel within the regions of Nirvana.

Whosoever raises the serpent over the staff must be chaste in thought, word and deed.

We must practice internal meditation daily. It is also essential that we do not consume alcohol. We must always be clean, always tidy, and always pure.

The two witnesses have the power to awaken the Kundalini.

These are the two olive trees, and the two candlesticks standing before the God of the earth.

And if any man will hurt them, fire proceedeth out of their mouth, and devoureth their enemies; and if any man will hurt them, he must in this manner be killed.

These have power to shut heaven, that it rain nor in the days of their

prophecy; and have power over waters to turn them to blood, and to smite the earth with all plagues as often as they will. Revelation 11:4-6

Those who are working with the Kundalini must have an unbroken faith in the Divine Mother. She leads her devotees by the hand. She leads her children from chakra to chakra.

She is the one who assists Gnostic students and teaches, approves, and prepares them so that they can Self-realize themselves.

Every devotee must beseech his Divine Mother so that she can grant him the sacred fire.

Then, after the advent of the fire, every devotee must meditate upon his Divine Mother daily.

The Divine Mother will teach her devotees, she will take them by the hand and guide them along the difficult path of the razor's edge. This path is full of hazards from within and from without.

The Swami Sivananda† gives us a useful prayer for meditation upon our Divine Mother. The prayer is as follows:

> **Oh Divine Mother, I am all yours;**
> **You are my only refuge and support.**
> **Protect me, guide me, have pity on me.**

You must know, oh brothers and sisters, that the Divine Mother will always respond. Without her grace, it would be impossible to carry the Kundalini from chakra to chakra and eventually reach the Church of Laodicea.

From The Mute Book, 1677

Chapter 4
Mantric Song for the Awakening of the Kundalini

There are sacred mantras that have the power to awaken the Kundalini. The angel Aroch, a commanding angel, taught us the most powerful mantric song that exists within the entire universe for the awakening of the Kundalini. When the angel sang this sweet and touching song, we were filled with ecstasy. The angel then invited us to follow his example, and we sang the mantric song, which is written as follows:

Kandil Bandil Rrrrrrrrrrrrrrrr

The mantric song is sung as follows:

Kan (resounding voice) *dil* (decreasing voice)

Ban (resounding voice) *dil* (decreasing voice)

Rrrrrrrrrrr (rolled)

The letter "R" should be vocalized as if imitating the sound of a high pitched motor, but with the sweetness of a child's voice. Brothers and sisters, this is how the song of the Kundalini is sung.

Everyone who is working with the Kundalini must not forget the letter "S." You must know, beloved brothers and sisters, that the letter "S" has the power to transmute the seminal liquor into distinct energetic values. The seminal liquor must be transmuted on a scale of seven types of energy - the seven degrees of the power of fire.

The letter "S" must be pronounced like a very fine and affable whistle. We must bring the teeth together in order to make a fine and delicate whistle. We must use this subtle voice; the yogi must learn how to intone and modulate.

The yogi must have Hermes' Glass hermetically sealed because the yogi who suffers from nocturnal emissions, or who fornicates daily or constantly, is like a person who wants to fill a bottomless pitcher or barrel. Therefore, the yogi must transmute the seminal liquor into seven types of energy.

The letter "S" has the power to transmute the seminal liquor on a scale of seven types of energy.

The Kriya of Babaji, the Yogi Christ from India, teaches about the power of the letter "S," the sweet affable whistle. The "still, small voice" that the yogi pronounces (which Elijah heard in the cave, Kings 19:11-13) is behind this very fine whistle.

The still, small voice is an even finer whistle. When the sound of this whistle reaches the cerebellum, it gives the yogi the power to instantaneously project himself within his Astral Body.

This is why the devotees who are working with the Kundalini must always practice with the letter "S."

The letter "S" transmutes the seminal liquor into the sacred fire of Kundalini when it is pronounced as a very fine whistle, as follows:

Sss

The mantric song of the angel Aroch and the sweet, affable whistle are absolutely necessary for the awakening of the Kundalini.

Chapter 5
Children of Wisdom

True Gnostic matrimonies can and must engender children of wisdom. Beloved disciples, please understand that the children of wisdom are not offspring of fornication.

When Gnostic matrimonies want to give a physical body to a great Master of the White Lodge, they then must inevitably descend into the ninth sphere with the Ninth Arcanum of the Tarot. This Arcanum is sex.

The mother of a child of wisdom must prepare herself for a period of nine months before she can create with the power of "Kriya-Shakti." During this period of time, she must be in constant prayer to the Divine Mother. She must beg her Divine Mother with all of her heart and soul to give her the joy of conceiving a great Master within her womb, one that will help humanity.

The mother of a child of wisdom must undergo nine months of preparation, chastity, saintliness and meditation before she can perform the sacred sexual act with her husband.

The father of a child of wisdom must not fornicate; he must also abstain from sex for a period of nine months.

The couple must be in constant prayer to the Divine Mother, beseeching her so that they can have the happiness of having a great Master as their child. They must be chaste in thought, words and action.

The sacred copula is performed in the spring during the month of May, the month of flowers. Throughout the duration of this month, the Buddha descends in order to bless humanity. The sacred sexual act must be performed on a Friday at dawn. The morning star is vibrating intensely at dawn.

The couple must complete the act without ejaculating the seminal liquor (without reaching the orgasm). The Lunar Hierarchy† knows how to utilize one masculine gamete and one feminine ovum in order to fecundate the womb.

The mother must sleep in a different position each month, one month on her right side and the following month on her left side.

This is how the body of the child, which is in the womb, will receive all of the cosmic benefits.

During the Lemurian epoch, this work was performed inside the great Temples of Mysteries. Painful labor during childbirth did not exist back then. This is how the children of wisdom were brought into the world. This is the "Kriya-Shakti" method for creation.

Now, with this very ancient method, which has been lost in the nights of the centuries, any couple that practices Gnostic Christian Yoga could give a physical body to a great Master of the venerable White Lodge.

This marvelous code evidently proves that it is not necessary to ejaculate seven million sperm in order to create a new human being. God said, *"Be fruitful and multiply."* God did not say, "Be fruitful and fornicate." Therefore, seminal ejaculation is a crime; seminal ejaculation is brutal fornication.

In ancient times, in paradise, reproduction was performed without seminal ejaculation, without the orgasm of man or woman.

The tenebrous lucifers of the ancient Earth-Moon taught the humans how to ejaculate the semen. This is how humans lost their powers. This is represented by Adam and Eve's departure from Eden.

Therefore, Gnosis does not teach anything that goes against Nature. Not spilling the semen is what is natural, what is normal.

Hence, Gnosis does not teach sexual refinement, it teaches what is truly natural and normal.

People are slanderous regarding this subject, because the philosophical stone is the stumbling stone; it is sex. It is the offensive rock for the evil ones.

Evil ones hate sexual magic. All that abolishes the simple satisfaction of their carnal passions repulses them. This is why they feel repugnance towards chastity.

Such is the law of these poor people. They live for the joy of carnal passion and they hate chastity.

Chapter 6
Urdhvarata

In India, sexual magic (Arcanum A.Z.F.) is known by the Sanskrit term "Urdhvarata."

People who practice the Arcanum A.Z.F. in India are called Urdhvarata yogis. The Great Arcanum is found in a Hindustani book entitled *Secrets of Yoga*. The author is a yogi from Southern India.

It causes us great horror to know that the tenebrous black magicians of the Drukpa clan (those who are dedicated to the fatal and horrible black tantrism) ejaculate the seminal liquor during their practices of black magic.

These black magicians have a fatal technique that enables them to reabsorb the spilled semen. Such a technique is known as black vajroli. This practice is completely negative; therefore we do not even want to explain the procedure. We know that there exist many people with very weak mentalities, who could easily be led into practicing such horrible black tantrism. Karma would then fatally fall upon us.

The spilled semen is mixed with feminine "verya" (feminine semen) and afterwards it is re-absorbed. Thus, it is horribly recharged with atoms of the secret enemy. These are satanic atoms that are collected from the atomic infernos of the human being.

The inevitable result of this black tantrism is the descent of the serpent towards the atomic abyss of Nature. This is how the human personality ends. It is definitely disconnected from its Divine Spirit. The human being is then transformed into a demon.

The Arcanum A.Z.F. (Urdhvarata) was practiced within the ashrams of ancient India. At that time, yogis were prepared for sexual magic with the white vajroli. Unfortunately, the brothers and sisters of the temple committed scandalous acts, which discredited sexual magic.

The Gurujis then pulled the curtains of esoterism shut, and the Arcanum A.Z.F. was forbidden.

However, the initiated yogis, male and female, secretively practiced the Arcanum A.Z.F.

Apparently even this was forbidden.

In reality, the decision to forbid the Arcanum A.Z.F. caused more damage than good, because the Brahmacharya system resulted in failure. This was due to the fact that no one was able to remain in Brahmacharya (absolute sexual abstinence).

Those who remain sexually abstinent supposedly keep their semen. Yet, they suffer from nocturnal emissions. This is how their accumulated semen is lost. Thus, these individuals turn themselves into victims of the abyss.

The Arcanum A.Z.F. is a system that helps to create strong, healthy, magnificent children.

The sperm that will fecundate the womb is selected with the Arcanum A.Z.F.

The one sperm that escapes during the practice of the Arcanum A.Z.F. is in fact a powerful and carefully selected sperm that will give origin to a true super human. This is how we can create a race of Gods.

With the Arcanum A.Z.F. we can completely develop all of the dorsal fires and develop a complete and deep realization of the Self.

H. P. B. (Helena P. Blavatsky), the great yogi, had to remarry after becoming the widow of Count Blavatsky. This was in order to practice the Arcanum A.Z.F. Only thus could she gain the development of the forty-nine fires.

Babaji initiated the Yogi-avatar Lahiri Mahasaya when he was married. This was how the Yogi-avatar achieved the realization of his Self.

The Gurujis of the ashrams must pay karma for not having spoken clearly when it was necessary to do so. Nothing was gained with the veiling of the sanctuary. It would have been better if they had the courage to speak clearly.

When the phallus and the uterus are united, we find the code of the Arcanum A.Z.F. It is essential for each individual to

withdraw from the sexual act without spilling the semen (without reaching the orgasm).

In life, do not ever spill Hermes' Glass. With this method we can convert ourselves into terribly divine gods.

Our motto is **Thelema** - willpower.

With the Urdhvarata, we awaken and develop the Kundalini completely.

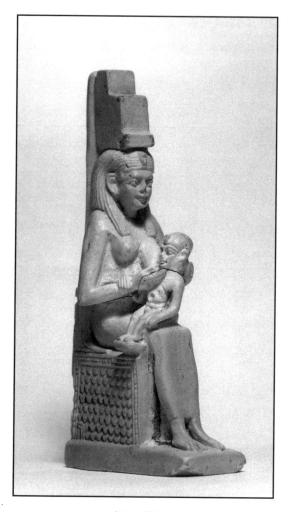

ISIS AND HORUS

The Divine Mother carries Her beloved
child in Her arms. Her child is the
Internal Christ of each human being.

Chapter 7
The Cosmic Mother

God does not have any form. God is co-essential to the abstract absolute space. God is that... that... that. God has two aspects, wisdom and love. As wisdom, God is the Father; as love, God is the Mother.

Christ is the Son of God. Christ is not an individual but an army, the Army of the Voice, the Word.

Before the dawn of the new cosmic day, Father, Mother, and Son were one; that...that... that.

God as Father resides in the eye of wisdom. This eye is situated between the eyebrows.

God as Mother resides in the temple of the heart. Wisdom and love are the two principal columns of the great White Lodge.

Within each human being there exists a soldier from the Army of the Voice. This soldier is the Internal Christ who exists in every man that comes into the world.

The human being with seven bodies is just the sinning shadow of the soldier from the Army of the Voice.

We must incarnate the Solar Man, the inner Christ. The Divine Mother helps us.

Ask, and it shall be given you; seek, and ye shall find; knock, and it shall he opened unto you. Luke 11:9

God as love is Isis, whose veil no mortal has lifted. Who would lift the terribly divine veil? Woe to the profane and profaners who attempt to lift the veil of Isis.

When the devotee beseeches his Divine Mother, he must be sleepy and submerged in profound internal meditation.

The true devotee does not rise from his bed, nor does he eat or drink until he receives the answer from his Divine Mother.

The Cosmic Mother has no form, but will take on any form in order to answer the supplicant. She can present herself in the form of Isis, Rhea, Cibeles, Tonantzin, Mary, etc.

When the Divine Mother has given her answer to the devotee, she then disintegrates her form instantaneously, because she no longer needs it.

The Divine Mother is not a woman, nor is she an individual. She is in fact an unknown substance. Any form that she takes disintegrates afterwards - that is love.

God, the Mother, is love. God the Mother adores us and loves us terribly. When we work with the Arcanum A.Z.F., the Mother Goddess of the world rises through the medullar channel and transforms Herself into the fiery serpent.

The Mother Goddess of the world is Devi Kundalini. The Divine Mother carries Her beloved child in Her arms. Her child is the Internal Christ of each human being.

The Mother is *that... that...* Isis... love... mystery...

The devotee who wishes to have powers must ask his Divine Mother for such powers.

The true devotee humbles himself before God, the Mother.

If the devotee sincerely wishes to correct his errors and tread upon the holy path, then he may ask his Divine Mother to pardon his past karma and She will forgive him.

Yet, if the devotee does not correct his errors or does not follow the holy path, then it is useless to ask for pardon for she will not grant it.

The Divine Mother will forgive her truly repented children. She can forgive the karma of her children because She knows how Her children behave.

The Divine Mother can forgive the karma of evil actions from past incarnations.

When repentance is absolute, punishment is worthless.

Chapter 8
Christic Egyptian Pranayama

Prana is the Great Breath. It is the Cosmic Christ. Prana is the life that palpitates within every atom, as it palpitates in every sun.

Fire burns because of Prana. Water flows because of Prana. Wind blows because of Prana. The sun exists because of Prana; the life we have is Prana. Nothing can exist in the Universe without Prana.

It is impossible for the most insignificant insect to be born, or for the smallest flower to bloom without Prana. Prana exists in the food that we eat, in the air that we breathe, and in the water that we drink. Prana exists within everything.

When seminal energy is refined and totally transformed, the nervous system is provided with the richest type of Prana. This rich Prana is deposited within the brain in the form of pure Christic energy, the Wine of Light.

An intimate connection exists between the mind, the Prana and the semen. We can gain dominion over the mind and Prana by controlling the seminal energy with the force of willpower.

Those people who spill the semen can never gain control over their mind, let alone Prana. Their efforts to gain control over their mind and over Prana will undoubtedly fail.

People who gain sexual control, also gain control of their minds and control of their Prana. These types of human beings reach true liberation. These types of human beings attain the Elixir of Long Life.

All of those immortal beings that live with the Divine Christ Babaji, Yogi of India, conserve their physical bodies for thousands of years. Death cannot do anything against them. These beings attained supreme chastity. This is how they achieved control of the mind and Prana.

Prana is universal energy; it is life, light, and joy.

The principal objective of the practice of Pranayama is to obtain the union of solar atoms and lunar atoms, which are found within the seminal system, and consequently to awaken the Kundalini.

Esoteric Exercise of Pranayama for Men

1. The disciple places himself in a chair or on the floor with his face directed towards the East.

2. The disciple prays to his Divine Mother with complete devotion and sincerity asking that she awaken him, awaken his Kundalini.

3. The chest, neck, and head should be in a straight or vertical line. Do not lean your body to the front, to the back or to one side. The palms of the hands should rest on your legs in a very natural position.

4. The mind of the disciple should be directed towards his Innermost, his Divine Mother, loving her, adoring her.

5. Close your eyes so that the matters from the physical world do not distract you.

6. Cover or close your right nostril with the thumb of your right hand. Mentally vocalize the mantra "**TON**." At the same time inhale slowly through the cavity of your left nostril.

7. Now, close the left nostril with the index finger of your right hand. Hold your breath; retain your breath. Mentally send the Prana to the temple of Ephesus (the Chakra situated in the coccyx, the small bone at the lower extremity of the spinal column) in order to awaken the Kundalini and mentally pronounce the mantra "**SA**."

8. Now exhale slowly from the right nostril mentally vocalizing the mantra "**HAM**."

9. Now close the left nostril with your index finger.

[EDITOR'S NOTE: Pronunciation must be as follows:
"O" as in "tone," and "A" as in "tall."]

10. Inhale the life, the Prana, through the right nostril mentally vocalizing the mantra "**TON**." Close both of your nostrils with your index finger and your thumb and retain the breath. Mentally vocalize the mantra "**RA**." Send the Prana to the magnetic center of the coccyx in order to awaken the Kundalini.

11. Exhale slowly through the left nostril mentally vocalizing the mantra "**HAM**."

12. This constitutes one complete Pranayama.

13. Repeat this complete process six more times (twice a day at dusk and dawn).

14. The devotee will kneel on the ground.

15. Once he is on the ground the devotee places the palms of his hands on the floor, the thumbs of the two hands together.

16. Prostrated on the ground, with his body inclined forward, with his head facing the East, and filled with supreme veneration he then places his forehead on his hands, Egyptian style.

17. Next, with his powerfully creative word, the disciple vocalizes the mantra "**RA**," the mantra of the Egyptians. This mantra "**RA**" is vocalized by prolonging the sound of its two letters, as follows: *Rrrrrrrrrrrrrrrrrr Aaaaaaaaaaaaa*. Vocalize the mantra seven times.

Esoteric Exercise of Pranayama for Women

1. The disciple places herself in a chair or on the floor with her face directed towards the East.

2. With complete devotion and sincerity, the disciple prays to her Divine Mother asking that she awaken her; awaken her Kundalini.

3. The chest, neck, and head should be in a straight or vertical line. Do not lean your body to the front, to the back or to one side. The palms of the hands should rest on your legs in a very natural position.

4. The mind of the disciple should be directed towards her Innermost, her Divine Mother, loving her, adoring her.

5. Close your eyes so that the matters of the physical world do not distract you.

6. Cover or close the left nostril with the index finger of your right hand. Mentally vocalizing the mantra "**TON**." At the same time inhale slowly through the cavity of the right nostril. [EDITOR'S NOTE: For pronunciation, see page 26].

7. Now, close the right nostril with the thumb of your right hand. Hold your breath; retain your breath. Mentally send the Prana to the temple of Ephesus (the Chakra situated in the coccyx, the small bone at the lower extremity of the spinal column) to awaken the Kundalini and mentally pronounce the mantra "**SA**."

8. Now exhale slowly from the left nostril mentally vocalizing the mantra "**HAM**."

9. Next, close the right nostril with the thumb.

10. Inhale the life, the Prana through the left nostril, mentally vocalizing the mantra "**TON**." Close both of your nostrils with the index finger and the thumb and retain the breath and mentally vocalize the mantra "**RA**." Send the Prana to the magnetic center of the coccyx in order to awaken the Kundalini.

11. Exhale slowly through the right nostril mentally vocalizing the mantra "**HAM**."

12. This constitutes one complete Pranayama.

13. Repeat this complete process six more times (twice a day at dusk and dawn).

14. The devotee will kneel on the ground.

15. Once she is on the ground the devotee then places the palms of her hands on the floor, the thumbs of the two hands together.

16. Prostrated on the ground, with her body inclined forward, with her head facing the East, and filled with supreme veneration, she then places her forehead on her hands, Egyptian style.

17. Next, with her powerful creative word, the disciple vocalizes the Mantra "**RA**," the mantra of the Egyptians. This mantra "**RA**" is vocalized by prolonging the sound of its two letters, as follows: *Rrrrrrrrrrrrrrrr Aaaaaaaaaaaaa*. Vocalize the mantra seven times.

The prior steps are all a part of Egyptian Pranayama.

The mantra **RA** has the power to vibrate the Kundalini and the chakras, the result being the awakening of the mentioned chakras.

The mantras of Pranayama are **TON – SA – HAM**; **TON – RA - HAM**. With this Pranayama, the Kundalini can be awakened.

With Pranayama we can come out of the darkness and become illuminated. With this Pranayama we can disintegrate laziness and dullness.

Prana is related with the mind. The mind is the vehicle of willpower. Willpower must obey the Great Soul of the Word. Our internal vehicles must be controlled by Pranayama.

Prana is life.

The right nasal cavity (nostril) is solar. The left nasal cavity is lunar. The two witnesses of the Book of Revelation are related to the nasal cavities. The two witnesses are a pair of nervous cords. The testicles (or ovaries in women) are united with the nasal cavities through these two nervous cords. We can say that the

two cords begin in the testicles (or ovaries). The two testicles are the two oceans of Life. Moses found his Master between the two oceans.

In this chapter, we have taught Egyptian Pranayama for the devotees of the occidental world.

Those who want to awaken their Kundalini must persevere in Pranayama and sexual magic daily throughout their entire life.

The room for the practice of Pranayama must not be humid, poorly ventilated, or unclean. The room should be pure, clean and neat.

Pranayama can be practiced in the country, in the mountains, and on the shores of lakes, rivers and seas. With Pranayama, we transmute the sexual energy into Christic energy.

With Pranayama and sexual magic, we awaken the Kundalini and the chakras completely.

Pranayama is a system of sexual transmutation for single persons.

Chapter 9
Sexual Transmutation for Single People

Yoga signifies "union with God." No one can achieve the union with the Beloved One unless the Kundalini has previously been awakened. No living being can awaken the positive powers of Kundalini unless supreme chastity has been reached. It is indispensable that we wash our feet with the waters of renunciation.

> *Strive to enter in at the straight gate, for many, I say unto you, will seek to enter in, and shall not be able.* - Luke 13:24

It is urgent to know that the straight, narrow and difficult door is sex. We departed from Eden through the door of sex, and only through this door may we re-enter into Eden.

Eden is sex itself. No one can enter Eden through false doors. We must enter through the doors from which we departed. This is the law.

The students of occultism who, for one reason or another, cannot practice with the Arcanum A.Z.F. must know the science of sexual transmutation in depth.

There exists a secret key, and with its help the single devotees can open the Ark of Science.

Practice of Sexual Transmutation for Single People

FIRST POSITION

The devotee of the path must imitate the position of the toad while situated on the floor.

SECOND POSITION

The devotees must lie down on their back, on the bed or on the floor, with their trunk or midsection elevated higher than the head. They must then inhale and inflate their lungs as if they were an angry toad.

MENTAL ATTITUDE OF THE FIRST POSITION

With willpower and imagination united in vibrating harmony, the Gnostic student must identify with a toad that is within a rivulet of the pure waters of life. He must also join his willpower and imagination in order to make his sexual energy rise from his sexual organs to the sacred chalice of the brain.

The Gnostic student must raise his seminal energy through the two sympathetic cords that are entwined around the spinal medulla. They form the famous Caduceus of Mercury.

MENTAL ATTITUDE OF THE SECOND POSITION

With willpower and imagination united in vibrating harmony, the Gnostic student must inflate himself as the toad does. This is only possible by taking a deep breath. During the inhalation of the vital air, we must imagine that the seminal energy is ascending through the two sympathetic cords, which are marvelously entwined around the spinal medulla.

The marvelous seminal energy must be directed towards the brain, and then directed towards the heart. We must then exhale the vital air, placing the energy in the temple of the heart.

Our motto is Thelema (willpower).

MANTRA OF THIS PRACTICE

Imitate the song of the toad. The mysterious croak of the toad is the song, it is the mantra.

ORIGIN OF THIS PRACTICE

The Divine Cosmic Mother gave this marvelous key of the Ark of Science to the Gnostic brethren.

The Divine Mother cares for all of her children. The toad that is upon the immaculate lotus flower, within the pure waters of life, is an archaic sexual symbol of the pharaohs of ancient Egypt.

Chapter 10

Order and Esoteric Discipline

The Gnostic must be temperate. He must not slander people. He should not be gluttonous or lazy.

As a rule, the Gnostic must retire to the bedroom at 10:00 p.m. daily, in order to practice internal meditation. The Gnostic must rise at dawn in order to practice all of his esoteric exercises.

The Gnostic must be a clean, tidy, decent, honest and upright person. He should always be punctual and happy, never angry with anyone, nor should he be against anyone in any way. The devotee should shower or wash himself daily, and he should dress presentably.

The Gnostic who never washes himself or is in great disorder causes damage to humanity in such a way that with his bad taste may drive people away from the Gnostic studies. For example, people might say, "If this is what Gnostics are like, I don't want to enter into these studies. I don't want to degenerate myself," etc.

The Gnostic must not be a fanatic. We must study everything in order to reject the useless and accept the useful. Gnosis is not against any religion, school, order or sect. We have fought for the moral purification of many religions, schools, orders and sects. We have never been against any religion, school or sect. We know that humanity is divided into groups and that each group needs its own system of particular instruction. All religions, schools, orders and sects are precious pearls that are strung on the golden thread of divinity.

We must build churches in order to serve all religions without distinction of names or creeds. Truly, all religions are ineffable and divine. All religions, schools, orders, and sects are necessary.

Religious jealousy is equivalent to passionate jealousy. It is a shame to be religiously jealous. The Gnostic brother or sister must overcome such jealousy, for it is a very vulgar passion. The Gnostic movement is structured for people of all religions, schools, orders and sects.

Neurosis is a very terrible sickness of the soul. In this epoch, people have become neurotic. Neurosis is satanic. We must cultivate sweetness, patience and love. We must educate our children with wisdom and love. In our homes we must cultivate happiness, sweetness and love because you must know that neurosis damages the lotus flowers of the soul. We must teach our children with examples; we should always be happy and joyous. Gnostic homes should be sanctuaries of love and happiness. Neurotic shouts and screams, weeping and crying destroy happiness, thus the white dove of love leaves the heart forever. This is the disgrace of many homes. Live with wisdom and love.

Chapter 11
Meditation

Once we heard an exotic declaration from the lips of a Hindustani Swami. The master explained the necessity of Hatha Yoga to the people in the auditorium. He explained how indispensable it was in order to reach the exaltation of Samadhi.

That Yogi stated that many people have not obtained success with internal meditation, despite their hard efforts and daily training. According to the Swami, such failures were due to the exclusion of Hatha Yoga.

Frankly, we disagree with this affirmation given by the venerable Swami.

Those who have not obtained illumination within ten to twenty years of serious practice within internal meditation must find the cause – which is the lack of the sleepy state. It is urgent to combine meditation with drowsiness.

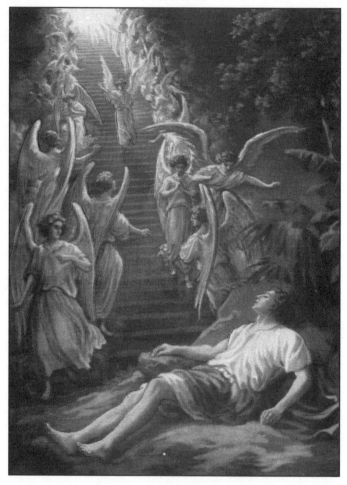

JACOB'S LADDER

There will come a time when the
devotee will see Angels, Archangels,
Thrones, Potentates, Virtues...

Chapter 12

Primary Clairaudient and Clairvoyant Experiences

If the Yogi persists with internal meditation constantly, tenaciously and with infinite patience, then within a period of time, clairvoyant perceptions will begin to develop. In the early stages of development, luminous spots will appear. Later, as the development continues, faces and objects and pictures of Nature will appear. Objects will seem dreamlike, as in the moments of transition that exist between vigil and dream.

The disciple's enthusiasm increases when clairvoyant perceptions begin to take place.

These perceptions inform the disciple that his internal powers are being activated.

It is extremely important that the disciple does not become weary. A great deal of patience is required for the development of internal powers. It is very difficult to develop internal powers. Many disciples begin this difficult process, but there are very few disciples who have the patience of Saint Job. Impatience will only impede our steps along the path towards realization of the Self. Such esoteric practices are for those that are tenacious and patient.

In the sacred India of the Vedas, Yogis practice internal meditation four times a day.

However, in our occidental world, due to the preoccupation with our daily lives, and the difficult battle for existence, if we practice meditation only once a day, then this is sufficient. Yet, what is important is to practice consistently, and without missing a day.

With intense repetition and tenacious practices, we will eventually put our chakras into rotation. Thus, after some time, primary clairvoyant and clairaudient perceptions will begin.

Luminous spots, pictures of light, living figures, sounds of bells and animals and the voices of people, etc. accurately indicate

the disciple's progress. These perceptions appear in the instant when the disciple is submerged in profound meditation and during the sleepy state.

Many types of light begin to appear with the practice of internal meditation. In early stages of development, the devotee perceives very brilliant white lights. These lights correspond to the eye of wisdom, which is located between the eyebrows. The white, yellow, red, blue, and green lights as well as lightning, the sun, moon, stars, sparks, flames, etc. are all particles which are forms of the supra-sensible elements (tanmatric particles).

When small luminous balls appear, shining with white and red colors, this is then an absolutely positive sign that we are progressing in our practices of concentration of thought.

There will come a time when the devotee will see Angels, Archangels, Thrones, Potentates, Virtues, etc. Within his/her dreams, while in meditation, the student may also see grand temples, rivers, valleys, mountains and beautiful enchanted gardens.

Commonly, during the practice of meditation, certain strange sensations occur that may fill the devotee with fear. One of these sensations is an electric shock in the chakra of the coccyx. Also the lotus of a thousand petals, which is situated in the upper part of the brain, will feel electric sensations.

The devotee must defeat this fear if he wants to progress in the development of his internal powers.

The time in which these visions appear depends on the individual himself. Some students have these visions within a few days of practice; others begin to have these visions after six months of daily exercises.

Within the first period of daily training we are in contact with the beings of the Astral plane.

Within the second period of esoteric training we make contact with the beings of the Mental plane.

Within the third period of esoteric training we are in contact with the beings of the purely Spiritual plane.

We then begin to convert ourselves into competent investigators of the superior worlds.

The devotee, who has begun to experience his initial perceptions in the superior worlds, must in the beginning be like a garden that is sealed with seven seals.

Those students who tell others about what they have experienced crumble in their studies, because the doors to the superior worlds become closed to them. One of the gravest dangers that attack the devotee is vanity and pride. The devotee fills himself with pride and vanity when he begins to perceive reality in the supra-sensible worlds. He thinks of himself as a master, yet he has not achieved the complete development of his internal powers.

He then begins to judge others incorrectly, according to his incomplete clairvoyant perceptions. The result of these incorrect judgments is a great deal of karma. The devotee attracts this karma to himself because he has become a slanderer of his own neighbors. He fills the world with pain and tears.

The student that has experienced primary clairvoyant perceptions must be like a garden that is sealed with seven seals. He must remain as such, until his Internal Master initiates him into the Great Mysteries and gives him the order to speak.

The devotee who is submitted to esoteric discipline also makes another grave error: He disregards imagination. We have learned that imagination is translucent. It is the mirror of the soul; it is divine clairvoyance. In order for the devotee to see, he must use his imagination. When the chakra of the forehead begins to rotate, then the images that are seen with translucent imagination become more brilliant, splendorous and luminous.

The devotee must distinguish between imagination and fantasy. Conscious imagination is positive, yet, fantasy is negative and harmful for the mind because it could lead us to have hallucinations or to reach madness.

Some wish to awaken their clairvoyance while disregarding imagination. If they disregard imagination, then they will fall under the same absurdity as those who wish to practice meditation without the sleepy state. These people fail to develop their internal powers. These people break the laws of Nature and inevitably failure is the result.

Imagination, inspiration and intuition are the three mandatory factors of initiation. In the beginning, images appear and in the end we penetrate into the purely Spiritual world.

Initiation is necessary for all clairvoyants. To have clairvoyance without esoteric Initiation leads the student into the world of delinquency. Therefore, it is urgent to receive the Cosmic Initiation.

If a clairvoyant penetrates into the subconsciousness of Nature, he can then read all of the past history of the earth and its races. He will also find his most beloved relatives. He may see, for example, his beloved wife married with other men. He may also see her committing adultery. If the clairvoyant has not reached Initiation, he may mistake the past for the present. He will then slander his wife saying, "She is betraying me, she is an adulterer. I am clairvoyant and I am seeing her in the internal worlds committing adultery."

All of the records of our past reincarnations exist within the subconsciousness of Nature.

If a clairvoyant penetrates into the infra-consciousness of Nature, he will then discover all of the evil of humanity.

The Satan of every human being dwells within the infra-consciousness of Nature.

If the clairvoyant has not received Initiation, he will then see the Satan of the Saints continually reviving the crimes and evil actions that the Saints committed in their ancient reincarnations, before they became Saints.

The inexperienced clairvoyant who is lacking Initiation cannot distinguish between the past and the present, or between the Satan of a human and the Real Being of a human, thus resulting in slanderous behavior.

The inexperienced clairvoyant may say, "That man believes he is a saint, yet he is an assassin, a thief and a terrible black magician. I know this, because I saw it with my clairvoyance."

This is precisely what we call a slanderer. Many clairvoyants have become horribly degenerated slanderers. One of the grave dangers of this behavior is homicide.

Within the infra-consciousness of Nature, a jealous, distrustful, and unworthy man will find that all of his doubts and suspicions are converted into reality. He then begins to slander his wife, friends, neighbors and masters saying, "You see, I have reason for my doubts, my friend is a thief, a black magician, and an assassin; my wife is committing adultery, just as I suspected. My clairvoyance never fails me, I am always right, etc., etc."

Due to the lack of Initiation, the poor man does not have the capability to sufficiently analyze in order to understand that he has penetrated into the subconsciousness of Nature. It is there where his own mental creations live.

Therefore, considering all of these dangers, it is necessary that the esoteric student does not pass judgment against anyone. Do not judge in order not to be judged. The devotee must be like a garden that is sealed with seven seals. Whosoever has primary clairvoyant and clairaudient perceptions is an inexperienced clairvoyant. Thus, if he does not know how to remain in silence, he will begin to slander others.

Only the great clairvoyant Initiates do not fall. Rama, Krishna, Buddha, Jesus Christ, etc., were truly infallible and omniscient clairvoyants.

DRAWING FROM A CODEX OF THE HILL OF THE CRICKET

Chapter 13
The Still Small Voice

There exists a particular mystical sound that the yogi must learn to hear. The Aztecs knew this mystical sound. Let us remember the hill of Chapultepec (note: *Chapul* - cricket, *tepec* - hill: "The hill of the cricket"). A cricket upon a hill is represented in a Mexican codex.

In ancient Rome, during the time of the Caesars, the cricket was sold in golden cages at a very high price. Magicians of ancient Rome bought crickets in order to employ them in practical magic.

If we place the cricket close to the head of our bed and meditate on its beautiful song, we will hear the "still voice" in the moment of slumber. This phenomenon is equivalent to the phenomenon of two pianos that are equally in tune. If for example we play the note TI on either piano, the other piano will repeat the same note without the touch of the human hand. This vibratory phenomenon is very interesting, and it can be proven by anyone. This exact phenomenon also happens with the mysterious sound of the cricket. In the human brain there exists the musical sound that resounds when the cricket sings. It is a matter of affinity and vibration.

To nourish this little animal is no problem. We know that the cricket feeds itself on vegetables and also with clothes found in homes. Many people are afraid of the cricket because they do not want to ruin their clothes. This animal can be easily found in the countryside.

Whosoever hears the "still voice" can travel instantly into the Astral plane at any time. If the devotee concentrates on the sound of the cricket, or if the Yogi meditates on the sound of the cricket and goes to sleep while listening to the sound of the cricket, the same mystic sound, tone or "still voice" will suddenly resound within his brain, and the doors of mystery will then be opened. During this instant, the Gnostic can naturally arise from his bed and depart from his home in the Astral Body.

What we are explaining must be experienced and understood in action not in thought or with the mind. The devotee must arise from his bed naturally. Nature will act by separating the Astral Body from the physical body. When we are out of the physical body, we feel a very light, delightful, spiritual voluptuousness. There is nothing more pleasurable than to feel the soul detached from the physical body.

In the superior worlds we can communicate with the ineffable Gods. In the superior worlds we can study at the feet of the Master. This is how we become free of many theories. This is how we drink from the fountain of living knowledge.

Every devotee must learn how to hear the "still voice." The devotee can perform marvelous wonders and prodigies with this mystical sound.

If the devotee wants to hear this mystical sound his concentration must be perfect. To begin with, the student will hear many sounds; yet, if he concentrates intensively on the sound of the cricket, eventually he will hear this sound and will attain victory. We inevitably attain illumination with this mystical sound.

In its final synthesis, this mystical sound comes from a tranquil heart. The origin of this remote, mystical sound must be searched for within the Divine Mother. The devotee must pray constantly, beseeching his Divine Mother to give him the ability to hear the great mystical sound.

With the grace of the Divine Mother, every devotee can have the joy of hearing the mystical sound that grants us the instantaneous projection of the Astral Body.

The devotee who wishes to perform these practices successfully must meditate internally until he truly feels the state of slumber. You must know that every esoteric exercise of meditation, if practiced with a lack of the sleepy state, is useless, sterile, because it damages the mind and harms the brain.

Therefore, internal meditation must be combined intelligently with the sleepy state.

If the Gnostic student does not have this marvelous cricket when practicing this exercise, then he must pronounce the letter "S." This letter must be pronounced like a fine and delicate whistle,

like this: *sssssssssssssssssss* (lips open and the upper and lower teeth together).

Behind this fine sound dwells the "still voice" that permits us to instantaneously project ourselves within the Astral Body.

The devotee should be in a very comfortable position in order to practice correct internal meditation.

We suggest two positions:

POSITION OF THE CORPSE

Lay down in the corpse position on the bed or floor, placing your arms along the sides of your body. Straighten the legs and bring the heels of the feet together so they are touching.

However, the toes of the feet should be separated towards the left and right, like a fan.

POSITION OF THE FLAMING STAR

Lay down in the position of a flaming star with the arms and legs extended towards the right and left. Your body must be very relaxed. You should resemble the figure of the five-pointed star. This is the position of the Master. Great Masters utilize this position for the practice of internal meditation. When in this position, the black magicians will run away with terror. When the Master arises from this position, the impression of the star remains in that place. This keeps the black magicians away.

The devotee must not meditate with a full stomach. It is necessary for the devotee to abandon the sin of gluttony. We must eat only three meals per day.

Esoteric Diet

BREAKFAST: Toasted bread with pure honey, hot milk and fruit.

LUNCH: Must consist of vegetables, fruits and any type of grain.

DINNER: Bread with pure honey and hot milk. Nothing more.

Meditation should he performed at 10:00 p.m. nightly. Meditation should also be performed at dawn. If the student meditates during these hours, he will progress rapidly.

Chapter 14
Jinn State

Hyperspace can be demonstrated mathematically with hypergeometry. Jinn Science belongs to hyperspace and to hypergeometry.

If we know what volume is, then we must accept hypervolume as the base of volume. If we accept the geometric sphere, then we must also accept the hypersphere.

Hyperspace permits Gnostics to perform extraordinary acts. Thanks to hyperspace, Jesus performed the extraordinary act of taking his body out of the sepulcher after three days. Since then, the resurrected Master lives with his physical body within hyperspace.

Every Initiate who receives the Elixir of Long Life dies, but does not die. On the third day, following death, he rises from the sepulcher utilizing hyperspace. The sepulcher remains empty.

The appearance and disappearance of a body in three-dimensional objective space, or the passing of a person through a wall, is performed with success when hyperspace is scientifically utilized. Gnostic scientists can place their physical body in the Jinn State and move consciously in hyperspace.

When the body of a Yogi is in hyperspace we say that he is in Jinn State. A Yogi can walk on fire without being burned when he is in Jinn State. He can also walk upon the waters as Jesus did.

He can float in the air. He can pass through a boulder or a wall, from one side to the other, without damaging his body.

Jinn Science is based on hyperspace; it is a special branch of atomic physics.

Ignorant people who have never studied hypergeometry deny the fact that the Jinn State exists. These types of people deserve to be pitied because they are ignorant.

Primitive geometry is based on the absurd hypothesis that on a plane, from one point to another, we can trace a straight parallel line, but only one line (speaking in elementary terms).

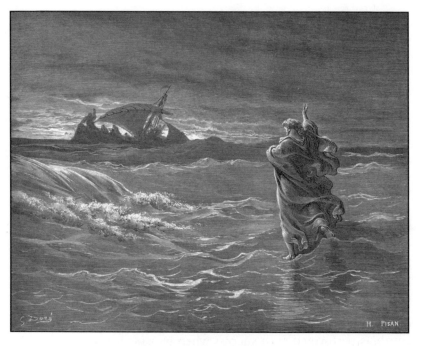

JESUS DEMONSTRATES THE JINN SCIENCE

We affirm that any human being can place the physical
body in the Jinn State, at any moment that he wishes
to, if he truly has faith in the Divine Mother.

The Gnostic movement rejects the Euclidean point of view, which only studies the three known dimensions. Such a point of view is totally primitive for this atomic era.

The so-called unique parallel line (speaking in an absolutely spatial sense) multiplies itself within the different dimensions of hyperspace. Therefore, it is no longer one unique line.

The single parallel of Euclid is just a sophism in order to trap ignorant people. Gnostics reject this type of sophism.

The Gnostic movement cannot accept this hypothesis, which cannot be demonstrated.

This hypothesis states: "From a given point in our mind, we can trace a real parallel line in the visible reality, but only one line." However, the unique parallel line does not exist.

The Euclidean hypothesis of the three-dimensional absolute and dogmatic space is unproven and false.

The absurd affirmation that the physical world of experimentation is the only real one results in there being a very common belief among the illustrious ignorant people (who have never investigated the electromagnetic fields and the so called pro-matter, as a *causa causorum* of physical matter).

The fourth dimension is hyperspatial. Gnostics have special techniques in order to place their physical body within hyperspace.

We, the Gnostics, affirm that the interplanetary infinite space is curved. We affirm that the infinite is in incessant motion. We affirm that there exists an infinite series of revolving spaces from different dimensions that mutually penetrate and co-penetrate without disorder. We affirm that all of the spaces of the infinite space have a hyperellipsoidal form.

We affirm that with the forces of the mind, the human being can place his physical body in whichever revolving hyperellipsoidal space he chooses. We routinely affirm that astrophysics will demonstrate to the world the existence of hyperspace. We also affirm that inside one line, hyperspatial lines exist.

We affirm that the Savior of the world lived within hyperspace with the same physical body that he had in the Holy Land.

We affirm that any Initiate who receives the Elixir of Long Life dies, but does not die. We affirm that all of those who receive the Elixir of Long Life will rise from the sepulcher on the third day with their physical body, thus taking advantage of the opportunity that hyperspace grants us.

These Initiates maintain their physical body for millions of years. The immortal Babaji and his sister Mataji have maintained their physical bodies for millions of years. They will perform great missions for humanity in the future great sixth and seventh root races.

We bluntly affirm that anyone who works with the Arcanum A.Z.F. can ask for the Elixir of Long Life. He who receives the Elixir of Long Life dies, but does not die.

We affirm that any human being can place the physical body in the Jinn State, at any moment that he wishes to, if he truly has faith in the Divine Mother.

Any sage of the elemental art (Jinn Science) can make the great jump. The Masters of Jinn Science can leave the earth in order to live on other planets with the same physical body that they have here in the third dimension. They can take their physical body of flesh and blood to other planets. This is the great jump. Some Masters of Jinn Science have already made this great jump.

With pranayama we gain the power to place our physical body in the Jinn State.

There exist many keys in order to place the physical body in the Jinn State. It is very important to practice Pranayama before using these keys.

It is important to know that the two witnesses, Ida and Pingala, in their final synthesis, are rooted in the right and left testicles of the male and in the ovaries of the female.

Through these two nervous canals, the solar and lunar atoms of the seminal system rise until they reach the chalice (the brain). The nostrils and the sexual organs are connected through the two witnesses. This fact invites us to reflect. Pranayama, among other purposes, is truly a system of sexual transmutation for single people.

Every Gnostic must begin practicing the Jinn Science, following intensive preparation in pranayama. The great Masters of Yoga levitate in the air while practicing pranayama.

The only body capable of floating in the air is the body that escapes from the law of gravity. Only the body that enters hyperspace can escape from that law. When mental force is consciously driven, the physical body can enter into hyperspace.

Jinn Science is a matter of vibration. Above and below the limited objective perceptions, there exist worlds that are located in other dimensions.

With the power of thought we can accelerate the oscillatory frequency and normal vibration of the physical body by means of certain keys of Jinn Science, which we give here. This is how we then penetrate with the physical body into hyperspace. When scientists gain absolute control over atomic movement, they will then place any physical object into hyperspace.

Prior to the practice of pranayama, the devotees of the Jinn religion must pray to their Divine Mother, beseeching her for the power to place their physical body in the Jinn State. They must practice Pranayama continuously in order to conquer the powers of Jinn State.

The student must carefully select the key that he prefers in order to practice Jinn Science.

It is absolutely urgent that the student comprehends that the Jinn religion demands absolute chastity and supreme sanctity.

Remember beloved disciple that the divine powers of Jinn Science are very sacred.

These powers can be utilized in order to cure and heal sick people from a distance. These powers can also be utilized in order to enter the temples of the White Lodge and study the marvels of creation within the womb of Nature.

Whosoever wishes to apply the powers of Jinn Science for selfish gain will convert himself into a horrible demon and will inevitably tumble into the abyss. The law is the law. Karma will punish the abusers.

The devotee must choose the key of Jinn Science that he prefers.

He must practice with this key daily, with great intensity, until he reaches victory. Jinn Science is not for the weak, the unsteady, fickle or inconsistent people. This science is for people who have as much patience as Saint Job. This science is for tenacious, courageous, alert and strong people who are strong as steel.

This science is not for skeptical people. Such people are useless for Jinn Science. This science should never be exhibited, for the White Lodge forbids it. Jinn Science is not to be displayed or demonstrated as a spectacle of magic. This science is terribly divine and can be practiced only in secret. When I, the author of this book, wanted to publicly demonstrate Jinn Science, the Master Moria immediately intervened by saying: "We have been teaching and helping you for the past ten years and now you want to exhibit your powers. Why? Powers are very sacred. Powers must not be exhibited to the public."

Since then we have understood that the Jinn Science is very secret. Many people would like to see demonstrations. We, the brothers and sisters of the Temple, are not experimental animals of a laboratory.

The truth is what one experiences within oneself. We cannot experiment with other people's bodies.

We give the keys so that each one can experiment this with their own flesh. We do not advise people who are filled with doubts, skeptical ones, to enter into these studies because they may go mad. The battle of tremendous contrast and opposition can destroy the brains of the skeptics; this may force them into a mental institution.

Therefore, Jinn Science is for those who have unbreakable faith, like steel. This science is not for people who are full of doubts.

For those who have strong faith, the keys to experiencing Jinn Science are as follows.

First Key

The devotee must lie down on his left side, resting his head on the palm of his left hand.

The devotee must fall asleep in this position. He must be on guard and aware of his dreams; he must become vigilant of his own dreams. When he begins to see the images of his dreams, he must arise very quietly from the bed holding on to the dream as if it were a precious treasure.

Before the devotee leaves his house, he must make a small jump with the intention of floating within the surrounding atmosphere.

If the devotee, after executing the small jump, floats within the atmosphere, then his physical body has entered into the Jinn State. If he does not float, then it is because he is not in the Jinn State.

When the devotee is in the Jinn State, he can leave his house with courage and confidence; in an instant, the devotee can travel to the most remote places on earth. If the devotee does not enter into Jinn State on the first try, then he must not dismay. Go to bed and repeat the exercise nightly, as many times as necessary, until success is achieved.

There are some devotees who will succeed immediately; these are the fortunate ones who have practiced Jinn Science in ancient reincarnations. Others may have never practiced the science. They must begin practicing pranayama and exercise this practice for many years, until they obtain this power. In reality, this key is just a modification of somnambulism (or sleep walking), it is voluntary yet induced somnambulism.

During dreams, tremendous subconscious energies are functioning. The devotee must take advantage of these energies and control them, like a lever, in order to place the physical body into hyperspace.

Second Key

There exists a nut commonly known as the Deer's Eye. This nut has marvelous Jinn powers. The devotee must go to sleep while holding this nut. He must place himself in the same position as given in the previous key, while holding this marvelous nut in his right hand. It is very important to remember that this nut has a marvelous elemental genie that can help the devotee to place his physical body in the Jinn State.

During this practice, the devotee must go to sleep pronouncing the mantra **INVIA**.

Then, the elemental genie will arrive and help him to place his physical body in the Jinn State.

The devotee must rise from his bed, holding on to the sleepy state as if it was solid gold.

Before he leaves his house, he must make a small jump with the intention of floating within the surrounding atmosphere. If the devotee floats, then he can leave his house in the Jinn State. If he does not float, then he must repeat the exercise for as many hours, months, or years that it takes until he achieves victory.

Third Key

There is a Master of Jinn State named Oguara. He helps anyone who calls him in the name of Christ.

The devotee must lie down in the same position, previously mentioned in key number one and number two. The devotee must call Oguara, the Master of the Jinn State, in the name of Christ, saying:

> *In the name of Christ, by the power of Christ, by the majesty of Christ, I call you Oguara, Oguara, Oguara. Please place my physical body in the Jinn State.*

The devotee must repeat this invocation continuously until he goes to sleep. The devotee must rise from the bed holding on to his dreams as if they were solid gold. He must then make a small jump, with the intention of floating within the surrounding atmosphere. If he floats, then he is in the Jinn State. If he does not float, then he must return to the bed and repeat the experiment.

Fourth Key

The devotee must sit in front of a table, he must cross his arms, place them on the table and rest his head on his arms. The devotee must invoke the Jinn Masters and ask them for help, so that that they may help him in his practices. He can call upon Babaji, the

Yogi Christ of India, or his sister Mataji; there is also Harpocrates, Saint Peter, etc., etc.

When the student begins to dream, he must rise from the chair automatically, instinctively and without thought. He must hold on to his dreams as if they were solid gold. He must then take a long jump, as far as possible, with the intention of floating within the surrounding atmosphere. After the devotee makes this jump, he must mark the exact place on the floor where he landed.

The student must perform this exercise daily, repeatedly and patiently. He must always mark the point on the floor, to measure the length of each jump. This system is marvelous because the student can appreciate his degree of progress in Jinn Science. For example, today the devotee's jump measured one meter, tomorrow his jump may be one centimeter more than the previous day, and the following day one centimeter more, and so on. Thus, the student is measuring his progress in Jinn Science.

Finally, one day he will discover wondrously, that he has performed an extremely long jump, an incredible jump that no athlete could perform. These are signs that clearly indicate his progress in Jinn Science. Following this incredible jump, the devotee can remain floating in hyperspace. Thus, he has victoriously succeeded. This key is marvelous.

What is important in occultism is to practice. Today, people are tired of theories. It is absolutely necessary to practice occultism now. People who theorize neither practice, nor do they allow others to practice. The student that has not wasted his time theorizing is better off practicing quietly and keeping his progress to himself. He must remain in silence, because this science is very secretive. It is better to remain in silence, therefore, we avoid the mockery and slander of foolish theorists who do not practice or allow others to practice. They are just social parasites.

Fifth Key

The instant in which the student awakens from his normal sleep, he must jump from his bed without any conscious or subconscious analysis, without the process of theoretical analysis.

It must be done instinctively. In other words, he must be ecstatic, full of wisdom and very strong faith, like the steel of the sword that is well tempered and ready for battle.

Upon leaving the house, the student must make a jump. If he floats within the surrounding atmosphere, then his physical body has entered Jinn State. At this point, the student can go wherever he wishes with his physical body in the Jinn State. If he does not float in the surrounding atmosphere, then he must repeat the exercise. With patience we can go very far in these studies.

Sixth Key

The Aztec Tiger Knights of ancient Mexico placed their physical bodies in the Jinn State with the assistance of the elemental strength of the tiger.

Some Mexican codices show the Tiger Knights traveling to the temple in the form of tigers. One codex explains that when the Knights arrived at the temple they again took the human form.

In ancient Mexico, the Temple of the Tigers was very sacred. The elemental strength of the tiger permits us to place the physical body in the Jinn State.

The student must lie down on a tiger skin while invoking the Devas who reign over the tigers. He must beg them for their help, for the strength of the tiger.

The Aztec devotees of the sacred order of the Tigers, while identified with the tiger, went to sleep holding onto their dreams as if they were solid gold. Then, they arose with their bodies, walking like tigers on four legs (hands and legs). Then, with great faith they pronounced: "We belong to each other."

Thus, with their physical body in the Jinn State, in the form of tigers, the Tiger Knights arrived at the temple. Once they arrived, according to the Mexican codex, they again took on the human form. The Yogis from India sit and meditate upon tiger skins.

According to the Aztecs, the first human root race was devoured by tigers (the tiger is a symbol of the divine force).

May the suns of enthusiasm enlighten your path.

May Xhcoc sing in your steps.

May the strength of the tiger keep you company.

May the sparks of wisdom illuminate your intellect.

May the whispering Picr be the shadow upon your retirement.

May the emerald frogs croak and direct you along the path without repose.

May She, Nature, be prodigal with you.

May the universal force bless you and guide you.

The occidental yogi lies down on the tiger skin while partially nude, and performs the esoteric practice of the Tiger Knights. This is how he enters into the Jinn State.

Seventh Key

Those who know how to travel in their Astral Body can invoke the physical body from afar. The first step the Gnostic must do with this key is to project himself in the Astral Body. When he finds himself far from the physical body he may call upon any of the great Masters of Jinn Science.

The devotee may ask the great Masters to carry his physical body to the Astral plane. He can invoke the Masters Harpocrates, Babaji, Mataji, Saint Peter, Oguara, etc., etc.

He must beg in the name of Christ, he must ask by the power of Christ, he must beseech by the majesty of the Christ.

The Genii of the Jinn State will then take the physical body from the bed and will bring it to the devotee who is asking for it. Prior to the arrival of the physical body, many bubbles will appear to the devotee. The final bubble is red, behind this red bubble comes the physical body in the Jinn State. When the physical body is near the student, he feels as though his shoulders are very heavy.

The emotion that the student experiences when the physical body is in front of him is tremendous. The greatest surprise comes to him when he discovers that his physical body also has consciousness and will respond to his questions.

In such moments, the devotee must dominate all of his emotions and control his mind so that he does not ruin the

experiment. If the devotee lets himself be driven by his emotions, then the physical body and the devotee will instantly return to the bed and the experiment will be ruined.

Table Work

In occultism, table work is the instant in which the physical body is invoked from afar and must inevitably enter the sidereal body of the devotee. This performance is very difficult because the body must learn how to do so, and the soul must dominate its emotions and know how to command the body.

The body must enter the soul through the coronary chakra, or lotus of one thousand petals, which is located in the upper part of the head of the sidereal body.

The devotee must command the body and the body must obey. If the body does not obey, then it is because it does not know how. So, the devotee must teach it.

The soul must command and teach the physical body to leave through the sidereal head of the Astral Body, and enter the devotee through the same door. The result is marvelous; the physical body obeys and enters into the devotee. In the Astral plane things are very different. It is not the devotee who must enter into the physical body; the physical body must enter into the devotee. This is how the devotee remains with his physical body in the Astral plane.

The Jinn system of the seventh key is for those who are very skilled in using and controlling the Astral Body.

With the physical body in the Jinn State we can visit the temples of the great White Lodge and receive direct teachings from the great Masters who initiated the dawn of creation.

This is what is known as practical occultism. Practical occultism is urgently needed by all.

The students of various schools of occultism are tired of theories. Unfortunately, the majority of students want to develop their powers easily, without any effort or sacrifice, comfortably within a short period of time, as if it were, so to speak, "a piece of cake."

We must be aware of the fact that life is very difficult and nothing is given to us for free.

The person who wishes to develop Jinn powers must have the patience of Saint Job, the courage of the tiger, the tenacity of the bull, and the inexhaustible thirst for divine wisdom.

This science is not for fickle people; it is better that such people remain out of these studies. This science is not for curious people either. We cannot play with cosmic laws without being burned. The law is the law and we must respect what is sacred.

Jinn Substances

There exist many substances that will help us in Jinn Science. The student of occultism must know what these substances are, and learn how to control them. Jinn Science is terribly divine.

The Orphic Egg, the Golden Egg of Brahma, the Egyptian Egg, etc., clearly symbolizes the prime matter of the Great Work. The universes, plants, animals, humans, and Gods come from this prime matter.

The egg contains great occult powers. The hen's egg is utilized for the Jinn State.

FORMULA

Warm the egg slightly in water; remove the pointy tip of the eggshell then remove the yolk and the white of the egg. Now we have to grind the empty eggshell into dust. This powder is utilized by the Yogis of Jinn Science.

Every night, before performing Jinn practices, the devotee must sprinkle the powder on his chest and under his arms or armpits. The student must then cover himself completely with clothing or bedding and begin practicing Jinn Science. The student must have a large quantity of this powder for practices. The great powers of Jinn Science are hidden within this powder. This powder is marvelous.

Sanctity

The student that is studying and practicing Jinn Science must inevitably stop committing the three sins: anger, greed, and lust. Only by doing so is it possible to avoid the attack of the tenebrous ones. If the student does not control these defects, then he will not progress in the true, positive, and complete sense of the word.

Vesture

Men who are working with Jinn Science must wear only yellow pajama pants (or loose fitting bathing trunks). The remainder of the body must be nude. Comfortable, loose clothing is best for Jinn practices because the chakras will spin freely.

WOMEN

Women who are practicing Jinn Science must wear only a loose fitting yellow robe that is as long and as wide as possible. The robe must be very beautiful, similar to the robes of the Samaritans. Women who practice Jinn Science must not cut their hair. The hair is a symbol of purity and chastity. In ancient times, a woman who committed adultery was punished by having to cut her hair.

Women practicing Jinn Science do not use the same vesture as men (i.e. bathing trunks) because it is immoral for them to do so. Divine hierarchies demand modesty, purity, and chastity.

WARNING

These yellow robes that are used for Jinn Science are not for Gnostic rituals. These robes are to he used only for Jinn Science practices and must be worn directly over the skin of the body. Absolutely nothing must he worn under this wide robe.

Chapter 15

Utensils and Perfumes

We must always use a specific room in order to work with Jinn Science, although if a specific room is unavailable the bedroom is sufficient.

The bedroom should be a true sanctuary. With chastity everything runs favorably.

The bedroom must be scented daily with the following five perfumes: frankincense, myrrh, aloe, sulfur and camphor. It is necessary that we paint the sign of the Pentagram, which is the five-pointed star, on the floor at the entrance of the bedroom. The two lower points of the star must aim towards the outside of the room and the upper point must aim towards the inside of the room. The star can be drawn with charcoal. We should also have a framed Pentagram above the head of the bed. It is very import that the superior point is aiming towards the ceiling and that the inferior points are aiming toward the floor.

The room must be decorated with yellow colors, for example, yellow curtains, walls, carpets, and lights. The Initiate must have yellow pajamas and in addition to this, a yellow robe.

We must have a picture of Christ, Buddha, and the Divine Mother.

The Divine Mother is represented as Isis, the Cosmic Mother of India, Tonantzin, or the white dove of the Holy Spirit. These pictures do not represent a divine or human person, they represent the Goddess Mother herself. We know that God as Father is Wisdom, and God as Mother is Love.

The Father resides in the Eye of Wisdom, which is located between the eyebrows. The Mother resides in the heart temple. The serpent entwined around the staff also represents the Divine Mother. It is important that we choose the symbol of the Divine Mother that we prefer.

The pictures of Christ, Buddha, and the Divine Mother must always he present in the bedroom or room of Jinn work.

We must have an altar in the bedroom and on this altar a fire must be burning at all times, whether it be a candle or an oil lamp. This is entirely up to the individual. The fire should always he burning in the house of the Initiate.

This is *The Yellow Book*. This is the wisdom of the Buddhas. This is the science of the Cosmic Mind.

The Buddhas wear yellow robes. The color of the Mental World is yellow. When the man is liberated from his four sinful bodies, then he is a Buddha. Every Buddha uses a yellow mantle. The ray of Christ is golden-yellow.

The science of the mind truly constitutes *The Yellow Book*. This is why this book is called *The Yellow Book* because the science of the mind is written here. In order to work with the science of the mind, the Initiate should retire to bed at 10:00 p.m. daily.

The Initiate must avoid discussions or arguments with skeptical people who do not practice or do not allow others to practice. The Initiate must avoid getting deeply involved with those who expect the world to rotate according to their beliefs, which are harmful and corrupt.

The devotee must bathe himself daily, to assure cleanliness. The room must be clean at all times. The room must always contain freshly cut flowers.

Flowers, perfumes, symbolic pictures, and beautiful music contribute to creating an environment filled with wisdom and love.

Jinn religion is very sacred. In this *Yellow Book* we have taught the sacred Jinn Science to all human beings.

Conclusion

With infinite happiness we have concluded this work. With humbleness, we offer this work to the poor and suffering humanity. It has been said that there exist three rays of the realization of the Inner Self. These three rays are: the Mystic ray, the Yogic ray, and the Domestic ray.

The beloved brothers and sisters of Gnosis, while resting on their staff, walk the three paths combined. Our motto is Thelema (willpower).

Beloved brothers and sisters, here we have an absolutely practical book on occultism. For the love of God, we, the brothers and sisters of the Temple, advise you with infinite humility not to waste your time theorizing. The opium of the theorists is more bitter than death itself.

Be humble in order to obtain wisdom. Once we have obtained wisdom, we must strive for even higher degrees of humility. Use the teachings of this book practically and you shall develop your divine powers. Beloved brothers and sisters, be consistent and patient; we must have absolute faith in our Divine Mother Kundalini. The Lady of all adoration guides her devotees from chakra to chakra.

When the igneous serpent of our magical powers awakens, the devotee passes six short but unforgettable experiences. These six experiences are: Divine happiness, a trembling body or body parts, astral projection, spiritual voluptuousness, coccyx pain, dizzy spells in conjunction with deep sleep filled with spiritual brightness.

These six signs indicate to the disciple the awakening of Kundalini. This is how the gardener waters the delicate internal garden with the sublime nectar of life, until the delicious fruits of Eden appear.

The Yellow Book is a guide for practical esoterism.

Beloved disciples, we must understand that this is a text, and a sure guide for the path of the Initiation.

Study this book and exercise these practices with intensity and supreme patience. Many occult powers appear with the awakening of the Kundalini. When this happens we must be careful not to fall

into pride. Once we have accumulated these powers, we must act as though we do not have them at all. We must recognize our own misery and sins.

We must find shelter within the nothingness. We are the sinning shadow of that which has never sinned. We must develop our internal powers, but we must dissolve the "I," the myself, the returning ego. By dissolving the "I" we can obtain complete liberation. The ego is a horrible larva that is present within the various levels of the mind. When the ego is dissolved, the great Lord of the Light enters the soul and dwells within.

We, the brothers and sisters of the Temple, feel great bitterness when we see a great Master who in spite of having awakened the Kundalini, still has the living "I" or ego within the profound levels of the mind.

Beloved brothers and sisters, this book will guide you to awaken your Kundalini and develop your occult powers. We must practice the exercises but we must also dissolve the ego.

Again, we must recognize our own misery and sins.

We must fast, pray, and walk with faith, patience, and charity along the difficult path that leads us to Nirvana.

Samael Aun Weor

Glossary

Being: "Our real Being is the inner Christ. Our real Being is of a universal nature. Our real Being is neither a kind of superior nor inferior "I." Our real Being is impersonal, universal, divine. He transcends every concept of "I," me, myself, ego, etc., etc." - *The Perfect Matrimony*

Ego: The multiplicity of contradictory psychological elements that we have inside are in their sum the "ego." Each one is also called "an ego" or an "I." Every ego is a psychological defect which produces suffering. The ego is three (related to our Three Brains or three centers of psychological processing), seven (capital sins) and legion (in their infinite combinations).

Lunar Hierarchy: Gabriel, the Regent of the Moon, commands the Lunar Hierarchy, all the Intelligences which manage the cosmic current related to the phenomena of birth.

Sivananda, Swami: Born in 1887 in the village of Pattamadai on the bank of the river Tamraparani in South India. He was named Kuppuswamy, and became a doctor who through his practice in Malaysia, actively served all levels of society. Once a Sadhu gave him a book "Jiva Brahma Aikyam" by Sri Swami Satchidananda. It ignited the dormant spirituality in him. He began to study the books of Swami Rama Tirtha, Swami Vivekananda, Sankara, *Imitation of Christ,* the Bible, and literature of the Theosophical Society. He was very regular in his daily worship, prayer and Yoga Asanas. Study of sacred scriptures like the *Gita*, the *Mahabharata*, the *Bhagavata*, and the *Ramayana* was done with great devotion. Sometimes he conducted Nandan Charitam and sang Bhajans and Kirtans. He practiced Anahat Laya Yoga and Swara Sadhana. He renounced worldly life, wandered across India, and took the vows of a renunciate (sanyasa) in Rishekesh, acquiring the spiritual name Swami Sivananda Saraswati. Swami Sivananda dressed to clothe himself, ate to live, and lived to serve humanity. A small dilapidated Kutir (hut), not resorted to by others and infested with scorpions, protected him from rain and sun. Living in that Kutir, he did intense Tapas (austerities), observed silence, and fasted. Often he fasted for days on end. He would keep a good stock of bread in his room, and for a week have this, together with Ganges water. He would stand up to the hips in the ice-cold Ganges in winter mornings and commence his mantra practice, coming out only

when the sun appeared. He would spend more than twelve hours in daily meditation. With all his intense Tapas, Swamiji did not neglect service of the sick. He visited the huts of the Sadhus with medicines, served them, and shampooed their legs. He begged food on their behalf and fed them with his own hands when they fell sick. He brought water from the Ganges and washed their Kutirs. He attended upon cholera and smallpox cases. If necessary, he kept vigil through the night by the side of the bed of the ailing Sadhu. He carried sick persons on his back to the hospital. With some money from his insurance policy that had matured, Swamiji started a charitable dispensary at Lakshmanjula in 1927. Swamiji practiced all the various Yogas and studied the scriptures. After years of intense and unbroken practice, he enjoyed the bliss of Nirvikalpa Samadhi. Swami Sivananda radiated his divine and lofty message of service, meditation and God-realization to all parts of the world through his books, running to more than three hundred, through periodicals and letters. His devoted disciples are drawn from all religions, cults and creeds in the world. He founded several organizations, all dedicated to the service of humanity. Swami Sivananda's Yoga, which he has significantly called the 'Yoga of Synthesis', effects a harmonious development of the 'hand', 'head' and 'heart' through the practice of Karma Yoga, Jnana Yoga and Bhakti Yoga. On the 14th of July 1963, the Great Soul Swami Sivananda entered Mahasamadhi (departure of a Self-realized saint from his mortal coil) in his Kutir on the bank of Ganga, in Shivanandanagar. (Edited from The Divine Life Society website)

White Brotherhood: That ancient collection of pure souls who maintain the highest and most sacred of sciences: White Magic or White Tantrism. It is called White due to its purity and cleanliness. This "Brotherhood" or "Lodge" includes human beings of the highest order from every race, culture, creed and religion, and of both sexes.

Index

Books by the Same Author

Aquarian Message
Aztec Christic Magic
Book of the Dead
Book of the Virgin of Carmen
Buddha's Necklace
Christ Will
Christmas Messages (various)
Cosmic Ships
Cosmic Teachings of a Lama
Didactic Self-Knowledge
Dream Yoga (collected writings)
Elimination of Satan's Tail
Esoteric Course of Runic Magic
Esoteric Treatise of Hermetic Astrology
Esoteric Treatise of Theurgy
Fundamental Education
Fundamental Notions of Endocrinology
Gnostic Anthropology
Gnostic Catechism
The Great Rebellion
Greater Mysteries
Igneous Rose
The Initiatic Path in the Arcana of Tarot
and Kabbalah

Introduction to Gnosis
Kabbalah of the Mayan Mysteries
Lamasery Exercises
Logos Mantra Theurgy
Manual of Practical Magic
Mysteries of Fire: Kundalini Yoga
Mystery of the Golden Blossom
Occult Medicine & Practical Magic
Parsifal Unveiled
The Perfect Matrimony
Pistis Sophia Unveiled
Revolution of Beelzebub
Revolution of the Dialectic
Revolutionary Psychology
Secret Doctrine of Anahuac
Three Mountains
Transmutation of Sexual Energy
Treatise of Sexual Alchemy
Yellow Book
Yes, There is Hell, a Devil, and Karma
Zodiacal Course
150 Answers from Master Samael Aun Weor

To learn more about Gnosis, visit gnosticteachings.org.

Thelema Press is a non-profit publisher dedicated to spreading the sacred universal doctrine to suffering humanity. All of our works are made possible by the kindness and generosity of sponsors. If you would like to make a tax-deductible donation, you may send it to the address below, or visit our website for other alternatives. If you would like to sponsor the publication of a book, please contact us at 212-501-6106 or help@gnosticteachings.org.

Thelema Press
PMB 192, 18645 SW Farmington Rd., Aloha OR 97007 USA
Phone: 212-501-6106 · Fax: 212-501-1676

Visit us online at:
gnosticteachings.org
gnosticradio.org
gnosticschool.org
gnosticstore.org
gnosticvideos.org